CW00502177

We Lost th

Ben Verii

Published by Nine Pens Press

2023

www.ninepens.co.uk
ISBN: 978-1-7391517-2-0

017

Contents

We lost the birds

A team of acousticians enters a wood. To replicate the sounds of the starling, they carry a 56 kilobit per second 8000 baud modem and a box of wind-up teeth. A recording of the BMW 3 Series locking mechanism and two pebbles clacked together constitute the alarm call of a nuthatch. For a blackbird at dusk, a wet rubber glove is smeared strenuously down a Perspex sheet. The wood fills up with darkness. Hypothesising that something is better than nothing, they drip water into a portable Butler's sink: a common chiffchaff. A rusty turnstile becomes a magpie; the 60.5 Acme Thunderer whistle, a thrush. The wood pigeon is a laboratory assistant with a throat infection calling from the fir copse through a mask at ten second intervals: *"I don't want to go. I don't want to go."*

Kingfisher

By the canal, watching the bird catch fire
in a dawn willow, I remember the night we jumped
a Grand Union humpback in a white Citroën ZX
Simon driving, kingfisher-blue eyes squinched in the mirror
warm dark slopping through open windows.
How righteous we felt, giddy
as gambolling water, come sunrise.
And when someone told us he had died
plunging that same car into a tree
how we fathomed luck was something
none of us possessed;
we are no more favoured than water.
The blessing is to believe oneself blessed
understand it does not exist
then feel it enter you, its wings pinned back.

Storms

So many, we ran out of names, resorted to common nouns: Justice. Confusion. Sacrifice. Trees squabbling. Rain-shot. Red kites collapsing onto all the things that died in the night. Resorted to phrases: Storm Serves Us Right. Magpies thrown into fences. Fences thrown into houses. Branches scraping the inside of your head. Funerals for moth traps. Funerals for trampolines. Funerals for birdsong. Trees screaming. Everything rifled, rummaged. Resorted to symbols: ! Only the crow, its tumbling laughter. What is left of us, underground with our tinned goods, listening to the wind grind buildings to sand.

Plumes

You wrote to say
that everything will turn out right
but in the Mojave desert
shimmer heliostats
one hundred and seventy thousand mirrors
the size of garage doors
attracting insects which attract small birds
whose feathers are set alight mid-flight
by the reflected heat. The workers
call them streamers.

Our ringtones are suddenly birdsong

All day we incubate a lightness
in our bones.

Heads cocked, we contemplate
in carriages, lull in colonnades.

Sympathetic architects sketch
perches for garden squares.

We rush mirrored surfaces
as traffic disperses a flock of commuters.

The lights of the Routemaster
prick out trench coats and court shoes

roosting on plinths,
among the boughs of planes.

Two buzzards over Sterling Wood

Some violence in the trees and they appear
caught between the branches' creel
and black breakers of crow

ponderous, tilted, harassed
all along the ridge and over the paddock
one calling to the other in that high plea.

The Honeyeaters

I tease the old Roberts' paint-splashed dial,
hunt for music in the static-forest
and you ahem complain your voice is tired,
too sore for scales and does the shopping list
include Ricola when accidentally
we catch the news – a package on regent
honeyeaters, now spread so thinly
on the western slopes of the Great Dividing
Range (just Mudgee-Wollar, Capertee Valley
up near Broke and Hastings-Maclearly)
to be critically endangered, the pale
yellow-speckled-breasted cock bird
learning its warble from an older male -
but the east coast has been interfered
into industrial estates, the white noise
and crowded emptiness of shopping malls,
freeway's brash hush, what's left of the bush
crackling alight each year - the birds cannot
locate a song and they are dying out,
which makes me think of your grandmother
(the one your family does not talk about,
who hides her face in the surviving photograph)
how her people up at Nyngan lost their dreaming songs
when the young were spread so thinly
between children's homes, Wangaiba land beyond
recognition now, the Bogan a low, green stench
as if it too has settled into the disquietude
that a world sung into existence can be silenced.

The Blessing of Throats

In Memoriam A.L.

Oh Saint Blaise, patron of Bradford,
veterinarians and throat disease,
to whom the sparrows gave their down
as a pillow for your hermitage,

just as Agricola of Cappadocia
had you flayed with an iron comb then beheaded
for performing the holy Heimlich
on a boy suffering from fishbones,

so my friend choked to death on a chunk
of honey-coated ham at a wake
despite two blistering tours of Iraq
and a refined sense of irony,

and just as condolences snagged in my gullet
so I failed to beg your intercession
when the stroboscope spotted the sulcus
in my wife's notes and she croaked home

terrified she would never sing again,
so I now hold this candle crucifix
to my throat and pray for words as useful, timely
soft as a feather leaves the body of a bird.

Pheasant

He is heraldic, parting the primrose and the wild garlic.
A sea of fern bows its mitres as he marches stately to the stump

bronze armour burnt pre-Raphaelite by the setting sun.
He sharpens his voice on the whetstone of dusk

to the woodpigeon's clattering applause. Sparks shower
the lambing fields and the last of the daffodils.

a hanging

moon yellow moths spin towards the station lights
flutter each other like eyelashes or soft kisses

high above the house white pigeons circle
six renegade pieces of the sun

you my friend were brilliant collapsed silent hunkered
then climbing back into the sky

the moths singe stutter downwards
torn paper rustling on black and silver tracks

a sparrowhawk is cold air breathed in sharply
smashed spirals and white feathers on the grass

when they cut you down you were birdboned
milky and delicate like a squab

Observations

A pair of swans and a damselfly.

She wants the flat and the dog.

It is a lovely day; I have walked eight miles from Once Brewed.

The last time I came, we came, Venus visible, raw in the daylight.

My solicitor charges £250 for the tour of an office smaller than this hide.

The water level is good for June, but the latch is rusty.

Have the reeds been cut back?

I could see this place from Hadrian's Wall.

We correspond by post; love turned to ink.

A wagtail bobs on the sphagnum moss.

It is a beautiful little thing.

Croak

It's not the sight of crow that unsettles me, but the croak.
Try it yourself. Fire up the chainsaw at the back of the throat

so the base of your skull vibrates. Kraa kraa kraa.
The last sound any of us hears or makes.

Valentine's Day, Edderside

The geese are flying north to breed
their skeins like arrows
shot from the south's spring bow
over the Solway Firth.
Love is where the head breaks off
and falls to earth.

High summer

So hot in the garden
that you wish the aircraft were thunder.
A locomotive dog draws up wontedly.
Swifts brake heavily on the turn,
spark against the sky.

If you listen hard enough
you can hear the earth crumble
and the grease-paper cigarette-paper
crackle of desiccating vegetable
beneath the predatory saws of wasps.

The day warps in the heat and starts skipping -
the brief arrhythmia of leaves
as a murder of crows
hunts among the eucalyptus trees.

From the shade of the wood
birdsong's detumescence
to a single pigeon
gurgling its long glass of cool white milk.

Sky burial

I am unravelled by knives behind a bamboo screen
while the monks recite me into their fat orange sleeves.

Mallets slap at the charnel ground.
The bone breakers sip sweet butter tea.

A gust gifts my matted tufts
to a passing pregnant crow.

The vultures' slow ascent
is a chant.

a couple kissing

on the corner of Woburn Place and Russell Square
meet with such force
that each kiss cuts
 a piece of them away

a lobe
 his blue eye
her hand

still stroking as it slaps
onto the pavement between Café Nero
and the red post box

 a knee rolls out
from his trouser leg like a hubcap

with her remaining fingers
she soothes a single hair from his collapsing face

the crowd of pedestrians at the traffic lights
don't seem to notice as they topple on
to their own
parts

but the pigeons do

Jenny Wren

A bobbing bright-eyed ball of songbird
in the hedge beside my house flings its chirrs
and scolds, notes sharp and hard as the tail end
of a terracotta wren on which my mum
hung her wedding ring when washing up.
This was her nickname among school friends
spotted in the foliage of Christmas cards
and a phrase I heard my father use just once
as he knelt beside the humming car
lifted her easily into the house
her gown opened like curtains to display
the welts where drunken mummer cells
performed the metastatic dance
of a wren-hunt on St Stephen's day.

Finally, the sparrowhawk arrives

At the end you were pinned to the spare room bed
limbs leathery and yellow as a songbird's
your breath startled
a savage pleading in the stripe of your eye
as if I could somehow intervene.

Go tell the bees

Go tell the bees
your mother's gone.
Our water tastes of wax.

Stripe the hive in black crepe.
Tap the roof three times
with the silver key from her sewing box

and ask to see the queen.
Tell her our colony's collapsed.
Beg her daughters swarm the news.

we brought you home

in a brown plastic urn
and unable to resist the urge
I peeked and spilt a speck of you
behind the sideboard in the dining room
thought of the jokes
tip in the ashtray look she's put on weight
wondered how much was you
and how much someone else's mum
mixed in to top you up
then we drove you to the beach
so Dad could pour you
into the Solway Firth
while I stood back with the dog
afraid he would dive into your wake
and I am not saying that you live
on in the veins of fish
or turn with the moon and the wind
but when I hear the waves speak softly
through the sea-bright stones
I think of you

Prisoners

Peter owned a maggot farm in a decommissioned prison
on the outskirts of Halifax. We peered through the mesh
of cell windows to watch a blaze of flies char each heap of beef.

He showed us the cow grinder where the inspector slipped
and lost a leg, a letter in green ink from a Brighouse widow
accusing his bluebottles of impregnating her stick insect.

I've been trying to escape the meat trade, he said,
ever since my Blackpool college days
where students made sausages for local B&Bs,

until the morning a landlady in rollers and an egg-stained pinny
burst into the Principal's office with a tiny message
her guest had found folded in his greasy Cumberland.

"Help!" it said. "I'm a prisoner in a sausage factory."

The quietest place on earth

is an anechoic chamber made of insulated steel
concrete and fibreglass wedges at Redmond, Washington
in which noise is measured by negative decibels and you become sound:
your breath is an electro-diesel train as it draws into a harbour town
your cartilage the rubber fender of a small green boat
which squeaks as you cast off from the quay.
That puck and slurp is your bilge pump heart.
Pleural fluid splashes in your thoracic cavity
like surf in the shallows of a small sandy island.
You expected fear but the blood through your jugular
is no stronger than a southerly through a brake of Maritime pine.
You can hear your thoughts - not the concepts or monologue
but the physical process of thinking. It is laughter and whistles.
A cork pops on the other side of the dunes.

Cooking omelette for Stalin's daughter

There is no whisk. I use a fork.
The kitchen, in an Elizabethan wing, smells of mould.
I fold the mess of eggs, sprinkle chives and salt.
The two old women sit in a room facing the salmon run,
the light dappled, confessional, my corner so dimly lit
I am unsure, after I serve, that they can see me or if they care.
I test my pen against the shorthand pad.
A creaking sense that something warps above our heads.
Mantel, desk, side tables are smothered in yellow papers
and photographs. Voices coagulate, separate;
the scrape of cutlery along porcelain, mutter of crumpled fabric
as Svetlana leans closer to the reiving REC of my recorder,
muddled with the red water of a river in full spate.

The smallest distillery in Scotland

Donaghy found me behind the whisky
stills and suffered my story: faith, boiled down
to a mash of schoolboy memory -
the creaking pew, shot of hymn, blood trickles down
the gaunt white lolling face, that feeling someone
famous just left the room. Highland monks,
he said, distilled the wort they christened
uisge beatha to treat colic and the mumps.
If the spirit failed, they would 'commend you
to the light, where all reliable accounts conclude'.
His words, repeated, flush my throat. There
was an ending - a refined measure of proof
conjured by an angel's share just before
he evaporated through the mould-black roof.

Impossibility of a sex poem

I no longer want to describe
what happened in the service lift of the Park Lane Hotel
the midnight beaches or how beautiful 'pull over after the bridge' is
in Finnish the aches deliriums upholsteries
the long walk home through snow in stolen clothes
even if I wanted to
and now you will consider these events when I am no longer sure
nor is there an adequate symbol
not a blind incomprehensible god to whom I fed the fat of my life
neither a helter-skelter nor phosphorescence
perhaps only an afternoon of rain
when shoals of kisses burst from her lips
laughter songs
the bed rocked by a lapping of tongues.

Acrylic eyes yellowing under strip lights in Acton

"Contrary to myth, Tussauds waxworks are never melted down to make new ones. They just go into storage." Daily Mirror, 21 October 2011

They came to mob whatever extract gave us power
scratch a nub of us beneath their fingernails
frot us in the darker corridors then splurge
our currency down the Marylebone Road
but now we are stocked in rows.
Don't get blood on my shirt! Kennedy jokes
as Cobain fondles a cartridge between fingertips
smooth as soap. In winter, our hair rots
but this heat oozes us out of lousy clothes
as we watch Rutherford on her knees hunting eyebrows.
Gorbachev's port stain dribbles to his ear
and Victoria's fat head sinks into black bombazine
like the sun going down on Empire.
No visitor in weeks, only traffic rumbling
in imitation of the touch-up artist's trolley
and, from the workshop, a sewing hive,
voices, the gulp of boiling wax
poured into moulds. *A revolution
is a struggle between futures and the past*
Castro replays. Voltaire is tongueless;
Ali, pinned by masonry bolts and webbing.
Frank won't leave the breeze of her open window.
Newman lost a hand. Even the Bonds are breaking.

The Crying Game

Well Barry, after testing positive for potassium and prolactin
the big man Griboyedov is back on Court One.
He returns from his ban to face the veteran Akin.
Can his pneumatic convulsions crack a face like porous limestone?
Huerta has been magnificent since the loss of his son
but he is up against number two seed Suheir-Hammad
who, as we know Barry, can command
the expulsion of basal, reflexive and psychic tears.
Unbandaged, she's on Court Two.
No one matches Nguyan Do for mucosal secretion.
The squalor of her bawl is unrivalled, her cheeks: cataracts.
She returns from a new diagnosis and six weeks off season
low attitude training at Point No Point to battle
the inscrutable O'Donnell on Court Three.
But never underestimate a nun, Barry.
Just look at the way her glottis contracts!
Those tears are of true contrition and constitute the sacrament.
She is back after a dry spell. On Court Four
this morning the newcomer Kadari
whose spasms so impressed in early rounds
faces Ocampo, her cries a jeremiad to the Dirty War
eyes an elephant's at the edge of a graveyard.
The favourite's lacrimal punctum floods
like a blocked storm drain in downtown Buenos Aires.
What joy she brings to crowds like ours!

Notes and acknowledgments:

Very many thanks to the tutors and mentors who helped me develop these poems: John Stammers, John Glenday, Glyn Maxwell and Tamar Yosellof. Thank you Sarah Gibbons for your wise and generous advice. With gratitude to the MA group for feedback on several of these poems. Thank you Colin Bancroft for finding them a home.

With acknowledgments and thanks to the publications in which the following poems first appeared:

'A couple kissing' – The Blue Nib Literary Magazine
'A hanging' – SOUTH
'The Honeyeaters' – Ver Prize 2021 competition anthology
'Kingfisher' – Ver Prize 2022 competition anthology
'The impossibility of a sex poem' – Un-seaming the tendon (2020 Winchester Poetry Prize anthology)
'The quietest place on earth', 'Cooking omelette for Stalin's daughter' – Stand
'The smallest distillery in Scotland' – Wild Court.

'Acrylic eyes yellowing under strip lights in Acton' won the 2022 Bournemouth Poetry Prize. 'Jenny Wren' was shortlisted for the 2020 Bedford Poetry Competition.

'Honeyeaters' and 'The smallest distillery in Scotland' owe a particular debt to the work of Michael Donaghy and, respectively, reference his poems 'Disquietude' and 'Exile's End'.